MARC JACOBS

© 2004 Assouline Publishing for the present edition
601 West 26th Street, 18th floor
New York, NY 10001, USA
Tel.: 212 989-6810 Fax: 212 647-0005
www.assouline.com

Color separation: Gravor (Switzerland)
Printed by *Partenaires-Livres*® (JL)

ISBN: 2 84323 630 4

MARC JACOBS

BRIDGET FOLEY

ASSOULINE

On a warm evening in May 2004, Marc Jacobs ascended the stairs to the stage installed at Pier 60 of Chelsea Piers, New York's famed sports facility that does double duty as party space for hire. The event was the annual benefit dinner for the designer's alma mater, Parsons School of Design, a fete at which the fashion industry elite gathers to celebrate both the year's graduating seniors and an icon of the industry, typically one of the school's own.

On this night, honoree Marc Jacobs commanded the microphone like a pro, giving no hint of the nerves to which he privately admitted, nor of his one-time loathing of the very notion of awards. Taking requisite fashionable license with the evening's mandated "black tie," he looked the essence of professorial hip in a dark sweater worn over shirt and tie, with hair grazing his shoulders and edgy eyeglasses delivering the right touch of cool authority.

Jacobs took the stage after an introduction by his good friend, director and Oscar-winning screenwriter Sofia Coppola, who put together a video montage highlighting the chic eccentricity of his work. For two decades, he had been in the forefront of fashion

news, long considered by industry insiders to be one of the world's most talented and influential designers, among the lauded handful to whom the rest looked for inspiration, or, in the vernacular of the trade, to knock off. Yet Jacobs had spent much of the past twenty years struggling to stay afloat in a volatile business that is often far from kind to fledgling designers. All of that changed in 1997 when Bernard Arnault, chairman of LVMH Moët Hennessey Louis Vuitton, tapped him to create a ready-to-wear presence for the storied accessories house and renowned cash cow Louis Vuitton. Jacobs's deal with LVMH bought the designer an international stage as well as a measure of security for his own label. The marriage, however, proved rocky at times, and both industrialist and designer fielded frequent rumors of Jacobs's dissatisfaction and eagerness to extract himself from the LVMH grip.

Yet on this night, Jacobs had every reason to feel supremely confident. He and his long-time business partner, Robert Duffy, had just emerged from grueling, often acrimonious contract negotiations with LVMH, and the next morning *Women's Wear Daily* would break the news that the pair had agreed to long-term contracts, virtually locking them into the French luxury conglomerate's world for the next ten years. Jacobs now stood before the audience as a designer of major artistic, and finally, financial clout.

This was not the first time he had been lauded by Parsons. Twenty years earlier, as a member of the class of 1984, Jacobs participated in the senior class group fashion show, winning recognition as Design Student of the Year for his brilliant project featuring huge

trapezoidal dotted sweaters. He also won two Gold Thimble Awards, presented from designer-instructors Chester Weinberg and Perry Ellis, whose name would figure prominently in his career. Sitting in the audience that night was a young businessman who worked for Reuben Thomas, a Seventh Avenue dress manufacturer. Robert Duffy was among the many onlookers blown away by Jacobs's extraordinary work, and one of several who rushed to phone the student marvel the next day, eager to interview him for a job. The two met and hit it off immediately. Duffy then convinced Thomas to launch Sketchbook, a contemporary sportswear collection, as a vehicle for Jacobs. Neither that line nor the relationship with Thomas lasted, but the Jacobs-Duffy partnership did, through a twenty-year roller coaster of incredible highs, lows, and ultimately, remarkable success.

I ronically however, the older, wiser Jacobs of 2004 commanded the stage on this particular evening only because the originally scheduled honoree, Tom Ford, wrought unintentional havoc on Parsons's party plans with his stunning exit from Gucci Group. It is customary for the school to celebrate a currently working designer, and when Jacobs got the call, he agreed to help. In fact, his first runner-up status could not have been more perfect, since he had spent two decades as the ultimate underdog, one who always connected with his client-fan base on a quasi-personal level.

That relationship is the reason Jacobs was able to stay in business—or keep going back into business—during the lean times. His clothes were just too good, and his adoring customers

too loyal, for him to fade away. Simon Doonan, legendary creative director for Barneys New York, sees in Jacobs the epitome of friendly downtown cool, an image captured in the store's long-running billboard campaign with a permanent home at the intersection of Greenwich and Seventh avenues in New York. *We love Marc Jacobs* screamed the initial version, followed in subsequent seasons by *They love Marc Jacobs, Girls love Marc Jacobs,* which featured a faux-nerdy wisp of a girl, and *Boys love Marc Jacobs* starring her freckle-faced brother.

"I thought long and hard about this brand before doing that billboard," Doonan said with several years' hindsight. "What's unusual about Marc Jacobs is that it's happy as well as edgy and chic. Historically, in fashion, those elements are most often mutually exclusive."

due to the simplicity and charm of its message, the Barneys mantra quickly approached iconic status. Still there, the billboard speaks volumes, certainly to the trendy types indigenous to the area, confirming what they already know about one of New York's homegrown designers, and to the millions of tourists and weekend visitors who take for granted the truth of the neighborhood's well-marketed cool: If the girls and boys of downtown love Marc Jacobs, he must be cool.

In addition, in its suggestion of sweet devotion, that tagline captures a basic reality: girls do love Marc Jacobs. They always have. Boys became smitten later. Jacobs made them love him with his continual embrace of the charming side of hip, one expressed variously as awkward, ironic, silly, punk, grunge, rock 'n' roll,

romantic, ridiculous, but almost invariably pretty, gentle, and at its core, optimistic. That affinity, coupled with the downright corny, against-all-odds pluck of a pair of determined business partners, is the reason the Marc Jacobs company now sits at the pinnacle of fashion.

Today, Jacobs's commercial might is indisputable, exemplified in the global buying mania that surrounded his Spring 2003 handbags for Louis Vuitton, on which he collaborated with Japanese artist Takashi Murakami. He is also the lone American clothing designer to have built a vibrant accessories business, one that took off with two handbags—"the Sofia," named for Coppola, and "the Venetia," named for Venetia Scott, longtime stylist of Jacobs collection shows and ad campaigns—and erupted in a few short seasons into a retail phenomenon.

f or years, however, commercial success proved elusive. Until Jacobs signed with LVMH, every move was touch-and-go and every collection could have been the last, even as the designer garnered near-constant editorial praise and remained a favorite resource for less creative peers. In fact, there were many last collections, as Jacobs went in and out of business several times before he turned 25.

And through it all, girls and boys loved Marc Jacobs, ultimately refusing to let him stay away too long. The first to the affair: young fashion editors who covered Jacobs relentlessly from the mid-eighties on, often to the chagrin of the higher-ups on the business side who had no hope of translating the designer's endless editorial credits into advertising dollars. What, exactly, did the editors see?

A high-profile American designer who spoke directly to them not only professionally, but as customers, while New York's establishment heavyweights focused their attentions elsewhere. Of the major names who dominated American fashion at the time, Oscar de la Renta and Bill Blass courted the traditional Park Avenue lady while Carolina Herrera and Carolyn Roehm played to their own contemporaries within the social set. Among more sportswear-oriented types, Donna Karan worked the angle of urban sophistication, Ralph Lauren delivered chic romanticism, and Calvin Klein, controlled, controversial edge. Only Perry Ellis honed in on a deliberately younger, festive aesthetic, although with a tony price tag.

J acobs offered something else altogether—a witty, celebratory attitude (at the time priced well south of Ellis) sprung from a frenetic collision of stimuli: the artistic vistas open to him early on as a well-to-do native New Yorker; the intense revelry of club culture in the late seventies and early eighties; an in-depth acquaintance with such pop culture kitsch as *The Brady Bunch*, whose faux family perfection contrasted with the real family issues in his own upbringing. The editors who first caught on to and covered his clothes sent the message out to the girls who longed to live the hip life depicted in magazines. Although Coppola would not discover Jacobs until his famed Spring '93 grunge collection, it was just that kind of personal connection that attracted her initially to his fashion and, later, to him as a friend. "This was the first time I saw something in *Vogue* made by someone of my generation," Coppola explained. "Marc was referencing things I cared about

that I hadn't seen in mainstream fashion before. One of the kids was making something that I was into, and I could feel that we liked the same kind of things, whether it was music or movies or art. You felt that connection in the clothes."

At the same time, a handful of retailers, ever eager to be first with the Next Big Designer, understood and supported Jacob's work. Thus, the reputation as New York's ultimate guru of hip settled on him almost immediately and hasn't lifted since. Yet what is remarkable about his clothes is that for all the reputation, little about them is inherently "edgy," a term that in fashion usually carries with it an undercurrent of anti-fashion and angst.

t he truth, despite the location of that Barneys billboard, is that Marc Jacobs has never really been a downtown designer. Rather, his designs are chic and subtle enough to appeal to a broad range of types, ages, and with the recent success of the Marc by Marc Jacobs collection, budgets. The clothes look right downtown, uptown, and all around the world. Nor, for that matter, has Jacobs ever been a downtown boy—at least not when it came to his address of record. He was born into urban affluence in 1963. When he was seven, his father, a talent agent at William Morris, died, and, for reasons the designer has always been reluctant to discuss, he soon left his mother's care to be raised by his adored paternal grandmother in her apartment in the Upper West Side's famed Majestic building. Despite long stints at ultra-cool downtown hotels later on, that apartment remained Jacobs's official residence until he sold it after moving to Paris.

Exposed to the social advantages of *tout* New York at a young age, Jacobs found his calling early on and went to one of the city's

renowned specialized schools, the High School of Art and Design. While there, he found a job as a stock boy at the store-of-the-moment, Charivari on Columbus Avenue and 72nd Street, run by the Weiser family, retail renegades with an ultra-forward approach to fashion. Jacobs relished people-watching and studying the trendy merchandise that he unpacked, folded, and shelved, and that flew out of the store.

t he experience only made him more determined to pursue a career in fashion design. Once, when Ellis—at the time the ultimate role model for aspiring designers—came into the store, Jacobs jumped at the chance to ask for advice. It came simple and direct: enroll at Parsons School of Design. This encounter proved prescient, as Jacobs would not only win the school's Perry Ellis Gold Thimble Award, but would also have a brief and infamous reign at the "House that Ellis Built." In between, a rapid series of events would establish Jacobs as one of the most talented and dogged designers ever to emerge from the New York system. His award-winning student designs proved so strong that Barbara Weiser commissioned a group for Charivari sold under the label "Marc Jacobs for Marc and Barbara." Then came the awards dinner at which, Jacobs would say much later, the school "unwittingly set me up with Robert Duffy," and his first real design-ing gig. Sketchbook debuted for Spring '85 with a giddy roar—an audacious, costumey ode to *Amadeus* followed by a dot-happy collection that featured witty, foppish designs and gigantic hand-knits emblazoned with indiscreet bright pink smiley faces. "I think the first time I saw the smile sweater I knew Marc would be a major star," said Ellin Saltzman, a revered industry veteran who, as then-fashion director of Saks Fifth Avenue, was instrumental in

launching the careers of numerous young designers. "There was nothing like his work in New York. Marc was on his way."

Jacobs was, in fact, on his way, albeit along a frighteningly rocky road. After just one year, Reuben Thomas wanted out of the young sportswear arena, leaving Jacobs and Duffy in designer limbo. They soon found temporary, and it would turn out disastrous, solace in Jack Atkins, a Canadian apparel executive whose promise of a bright future proved empty. Though "poor deliveries" were cited, the real reason for the dissolution of their deal was that, apparently, Atkins was broke all along, putting Jacobs out of business again. The next few seasons saw deals with a concern called Epoc 3 as well as Kashiyama USA, and a series of events worthy of a tortured fashion Job, as a massive fire, theft, and a pesky U.S. Customs department devastated various collections.

Through it all, editors kept featuring Jacobs's work and retailers kept returning to whatever new situation in which he found himself. "The clothes always had a lot of verve," said Kal Ruttenstein, Bloomingdale's senior vice president of fashion direction. "Yet he developed them with an increasing undercurrent of elegance."

m eanwhile, Perry Ellis had died in 1986, and the company hired as his successors then-assistants Patricia Pastor and Jed Krascella. Krascella soon left to pursue an acting career, and critics considered Pastor's work too safe to carry on the Ellis legacy. She was fired in 1988 and Jacobs, at the still-green age of 25, hired. Duffy accepted the position of president of the collection.

The story of the pair's brief tenure at the house has become part of fashion lore. Certainly given the wit and exuberance of his work,

Jacobs seemed a worthy heir to Ellis, and the corporate suits who made the appointment, positively ingenious. The ascent was not without its awe-shucks element as the engaging young business partners seemed finally to have attained some security. Or so everyone thought. While on their own, Jacobs and Duffy had operated like a pair of fashion Andy Hardys, embracing that character's "Hey kids, let's put on a show" can-do spirit. Together, with the help of only one assistant, Anita Antonini, they did everything it takes to produce a collection, from sourcing fabrics to securing production and shipping to, yes, putting on their shows—casting, music, seating, and the like. Now, suddenly, they had a real staff. "I'm waiting for someone to go to the bathroom for me," Jacobs was fond of saying.

t he press went crazy over the appointment. *The New York Times* wrote that by hiring "a dynamo of a designer" who had "spent the last several years hanging by his fingertips, doing all the chores from designing to scrubbing the floors for various underfunded firms," the company had "a chance to charge back into the top ranks." *Newsweek* reported that "in a recent move that wowed Seventh Avenue, the Perry Ellis Sportswear company bet its future on a relative child." The kid felt the pressure. "This is the wildest thing to happen in my life," the newly installed designer told *WWD*, and to *Manhattan, Inc.*, "I'm petrified. I feel like I have the weight of the world on my shoulders."

Perhaps not surprisingly given the pressure and expectations, Jacobs's first collection for Perry Ellis proved less than stellar. Rather than pout, he chalked it up to a learning experience, even writing notes to fashion critics thanking them for their opinions.

He acknowledged that he had spent too much time concerned with staging a big-time blockbuster rather than focusing on the clothes. "I did what I felt I had to do," he said while readying his second Ellis collection. "I thought everyone expected this incredible show of energy and spirit. I concentrated on that, and not enough on the consistency of the collection in terms of shapes and proportions." He was determined to alter that approach for the future, and progressed over the next few seasons through a series of inspirations—Mia Farrow, Upper East Side lady with a soupçon of Doris Day, the Wild West of Los Angeles—showing increasing sophistication without losing a bit of his characteristic irony, and without giving into the urge to play it safe.

S afety was the furthest thing from Jacobs's mind as he designed his Spring '93 collection. Consciously or otherwise, the designer's musical passions have always informed his work. (To wit, he titled one of his most delightful collections "Rock and Roll Circus," in overt homage to the Rolling Stones's infamous 1968 concert.) As a cool fashion kid about New York he reveled in the city's club culture, frequenting the famed Area and other dance clubs as a high-profile regular. Along the way he found inspiration in artists including Blondie, whose lead singer Debbie Harry would become a close friend, Iggy Pop, and Sonic Youth. His tastes proved broad, from Serge Gainsbourg right up to the White Stripes's Meg White. But no musical genre would impact his career as dramatically as the coarse, anti-fashion movement that exploded in the early nineties from its home base in the Pacific Northwest. Jacobs responded intensely to the angsty, dissonant chords of grunge. So much so that it inspired a spectacular collection, one

that featured floaty, flowery dresses, silk "flannel" shirts, shrunken tweed jackets, and knitted caps, all tossed together in seemingly random combinations, often over satin Converse sneakers or clunky army boots. Yet despite the deliberately undone aura, Jacobs kept the clothes beautiful and the mood upbeat instead of angry.

Fashion insiders—or at least the editorial part of the insider equation—went wild for the audacious new look. So did some retailers; right after the show Bloomingdale's Ruttenstein proclaimed it one of Jacobs's best collections ever and pronounced, "We're coming back tomorrow for windows."

a s it turned out, haste was of the essence. The collection proved revolutionary, shaking fashion to its core and disrupting many commonly held notions of what constitutes designer-level chic. The effort even garnered Jacobs his first Womenswear Designer of the Year Award from the Council of Fashion Designers of America. It also earned him a pink slip. Despite Ruttenstein's enthusiasm, many retailers wondered whether women would break out the plastic for expensive clothes that looked "poor." Perry Ellis executives suffered no such conflict. By their lights, grunge spelled disaster. Jacobs had to go.

It became one of the most notorious firings in fashion history, one that put Perry Ellis out of the women's designer business, and Jacobs and Duffy once again out of work.

But girls love Marc Jacobs. So, too, do women in high places in the fashion industry. "You can't change fashion by parading twenty-five navy suits down the runway," said *Vogue*'s Anna Wintour, over the years a staunch Jacobs's supporter. Thus, yet

another hiatus was viewed as just that, as everyone in the industry knew he would be back.

On his 31st birthday, Jacobs showed a spectacular comeback collection for Fall '94, one he characterized to *WWD* as "a little funky, a little trashy, and a little chic." His future work would retain such convergent elements, even as it increased in grace and sophistication. Here, however, laminated sequined jeans, rubber trench coats, and oddball pairings of quirky skirts and sweaters looked charmingly awkward, but with more than the "little chic" the designer had promised. For this show, Jacobs and Duffy reverted to their early ways, showing on the proverbial shoestring in a friend's downtown loft, their good humor apparent in a blatant pitch for business: supermodels *du jour* Shalom Harlow and Amber Valletta (top models routinely walked Jacobs's runways in exchange for clothes—a sure sign of a designer's insider appeal) closed the show as a tuxedoed bride and groom, Valletta's jacket flaunting the company's phone number in diamonds on the breast pocket. The collection rocked, and put Jacobs back in business for good.

t he next few years saw a dizzying upward trajectory. Jacobs frequently explored retro themes, especially in an affinity for seventies motifs that became a hallmark of his work. Season after season he increased the collection's luxe factor, along the way creating some near-instant house classics such as casually indulgent cashmere thermals and ultra-chic tweeds. Among those to take notice: the daring industrialist Bernard Arnault. In 1997, he signed Jacobs to develop a ready-to-wear business for Louis Vuitton, revered producer of timeless, indestructible, and decidedly unfashiony monogrammed leather goods. At first it played out as

something of an unholy alliance, the company executives beneath Arnault skeptical of this intrusion into their wildly successful, apparel-free world. Jacobs got off to an oh-so-serious start, filling his first runway collection with the pale gray trappings of high-fallutin' intellectualism and all but avoiding the LV monogram.

but he soon shifted gears toward an attitude of jet set glamorama. Suddenly, the clothes sparkled with color and bravado, and the accessories, with boundless energy. Jacobs not only embraced the house signatures but dared to toy with them. He first worked LV-embossed patent leather in riotous colors and gigantic proportions, and later embarked on a series of blockbuster collaborations. Designer Stephen Sprouse graffitied the classic monogram in Day-Glo. Artist Julie Verhoeven let loose with butterflies and snails in arts-and-crafts collages. And for Spring '03, Jacobs engaged Japanese artist Takashi Murakami to unleash his sweetly subversive cartoon whimsy on the Vuitton logos. "I wanted everything to be joyous," Jacobs told *WWD* before the show. "People should feel good when they see these things."
Joy takes many forms. The collaboration resulted in one of the biggest fashion coups in memory as everyone from Madonna to Jennifer Lopez to Naomi Campbell soon hit the paparazzi-dense streets Murakami bag in hand, garnering Vuitton momentous publicity. The sensation led all sorts of legitimate accessories companies to copy the look—along with legions of opportunistic counterfeiters who flooded New York's Canal Street with contraband copies, ultimately leading to an investigation by the Department of Homeland Security. Jacobs had spun leather into gold.

While embarking on the gleeful Vuitton ascent, Jacobs and Duffy remained focused on the New York-based Marc Jacobs business. They made their move into retail, first with a store on New York's Mercer Street, then launching a dazzling accessories collection, and, for Spring '01, a secondary line, Marc by Marc Jacobs, which would set a new standard for the "contemporary" arena, a category of clothing priced well below designer. (Another secondary line, Marc Jacobs Look, was already flourishing in Asia.)

Yet all was not bliss. Jacobs had long battled personal demons, perhaps rooted in the instability of his early childhood and fueled by his embrace of the darker side of a rock 'n' roll lifestyle. The fashion business swirled for years with rumors of his drug use, but these found only rare anecdotal support in weak collections; for the most part, the collections remained stellar. Nevertheless, immediately after the showing of the Vuitton Fall collection, in April 1999, Duffy brought Jacobs back to the United States and checked him into a rehab center. "I used to be a really wild person," the designer said to *Harper's Bazaar* two years later, after his release.

Jacobs emerged fit, healthy, and ready for a sober future. "I saw the light," he told the *London Times* in April 2004. "And I straightened up my act. I don't touch either drink or drugs now. I know that I can't go back, not for a second. When people ask if I want a drink, I just say, 'No, thanks. I've had enough already.'"

Meanwhile, he had developed an affinity for the comforts a Paris-based life had to offer. Early in his relationship with LVMH he had loathed the City of Light, resisting its language and resenting its

slower pace and what he perceived as an oppressive authoritarian aura *chez* Vuitton. But his opinion changed as he grew more secure with his role at the house and more accepting of his often-grueling trans-Atlantic commute. He found himself spending more and more time there, finally realizing that he had, in fact, moved. "Paris is soothing," he would later say. "It's a place where it feels good to have a calm, quiet life."

a tragic antithesis to that Parisian calm occurred during the Spring '02 season. As always, Jacobs's Monday night show was the first major event on the New York calendar. He had flown in from Paris and checked into the Mercer Hotel, his home base during two weeks of fittings. Years earlier, he and Duffy had taken to throwing small "friends-and-family" post-show parties at the divey-chic restaurant Paris Commune. This season they opted for a major bash in support of several charities while also celebrating the launch of their first fragrance. Thus, the show, a delightful romp rooted in the seventies with a nod to Gustav Klimt, preceded a cast-of-thousands celebration under a huge tent pitched in Hudson River Park, a usually sedate strip of green along Manhattan's West Side Highway. The affair ran late and wild. The next morning, the World Trade Center was attacked. Common sense and decency prohibit pat observations on a fashion world shocked suddenly into a proper sense of perspective. Yet for those who were there, the memory of Jacobs's show and party on September 10, 2001 will stand forever as one of life's great innocence-lost moments.

Fashion was hit hard by September 11th and its aftermath, not only emotionally but also financially, impacted as well by other factors fueling a soft economy. Yet as the first decade of the new century

nears its midpoint, the luxury sector has rebounded into a position of impressive strength. Today, both the Vuitton and Jacobs businesses are flourishing. Jacobs's trips to New York remain frequent as he continues to preside over a remarkable run at his eponymous house. There, his aesthetic has evolved in an increasingly refined direction while continuing to offer an intriguing fusion of dichotomous traits—hip and pretty, young and sophisticated. This has made his work not only an editorial favorite but a must-wear for *au courant* Hollywood—a relationship developed without the aggressive L.A.-based PR offensive other houses employ. Meanwhile, Marc by Marc Jacobs has made the Jacobs attitude accessible to legions of young fans, and as for those fabulous handbags, it seems that nobody can get enough of them.

n ow, committed for the long-term to LVMH, Jacobs and Duffy want to expand the Marc Jacobs business. They plan to increase their stable of stores, broaden the reach of Marc by Marc Jacobs, and perhaps launch a third, still lower-priced, line. If and when that happens, one can only imagine the customer reaction. Because just as when Jacobs brought those college-project sweaters to Charivari, girls and boys—and the women and men they grow up to be—continue to love Marc Jacobs.

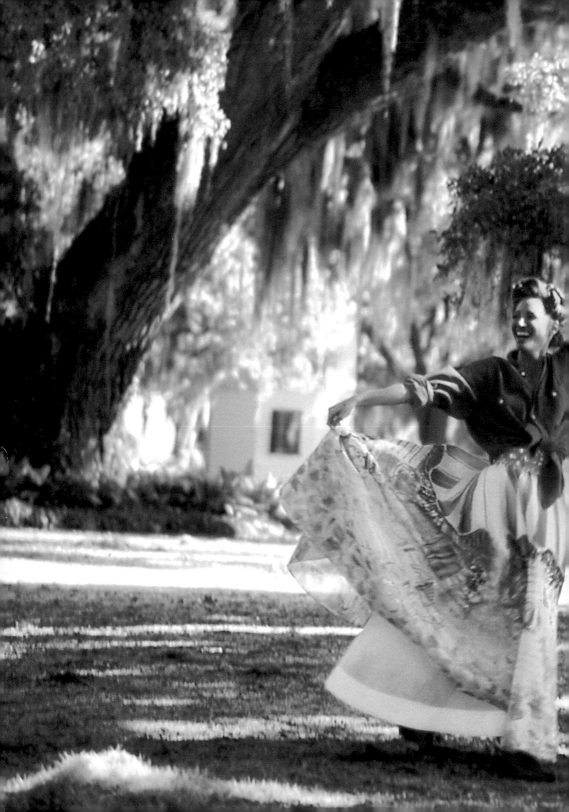

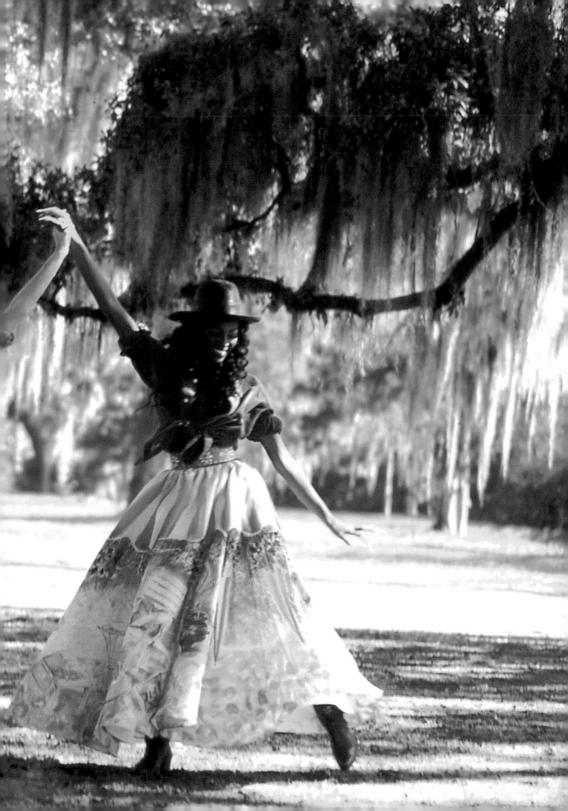

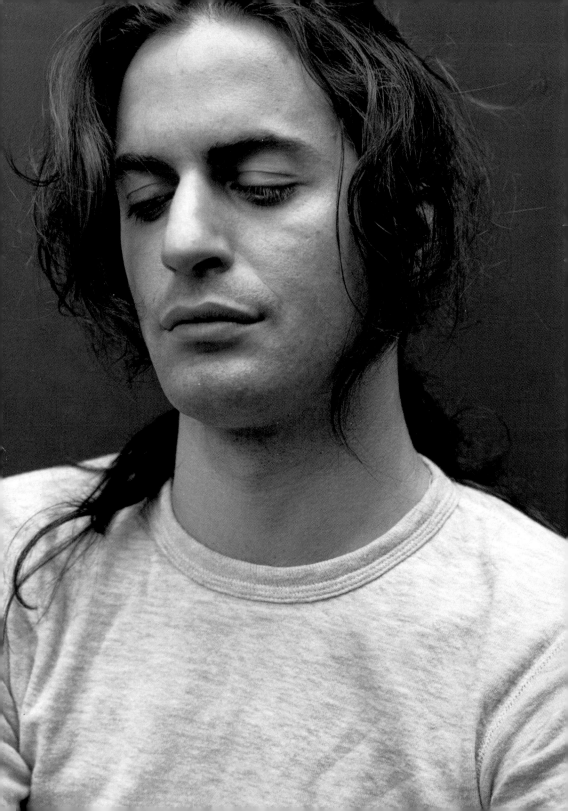

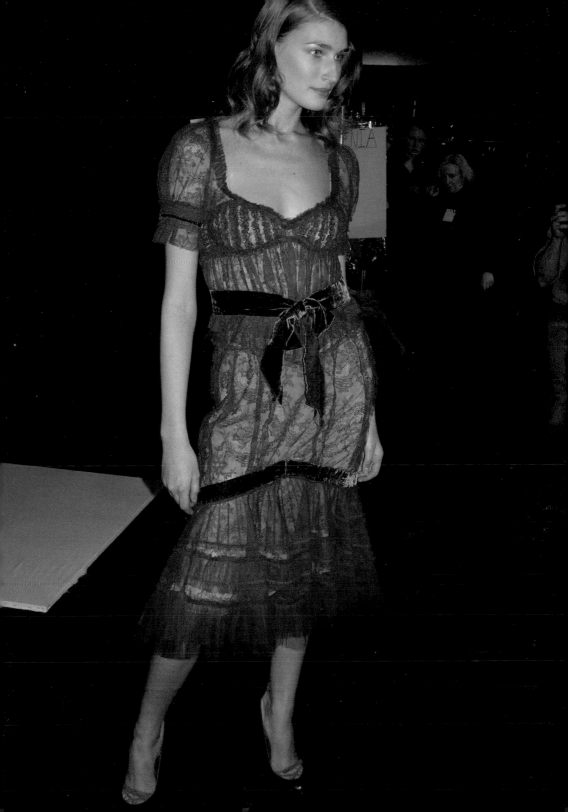

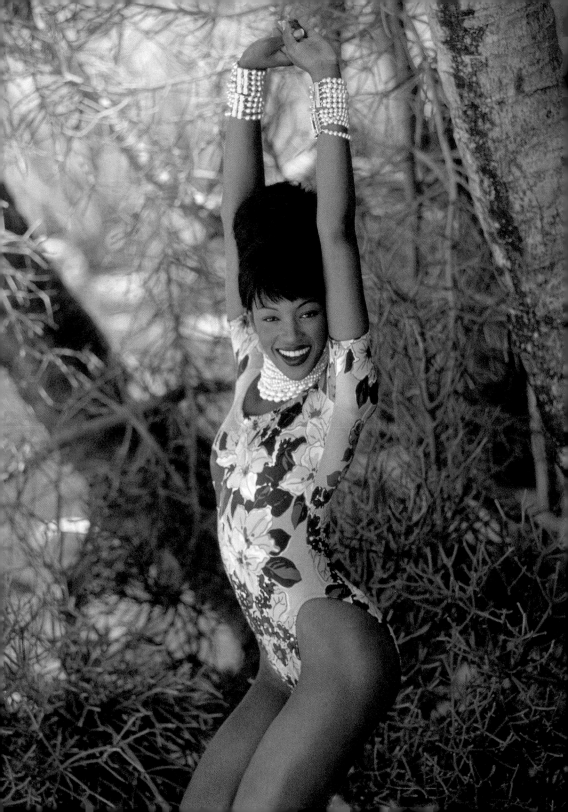

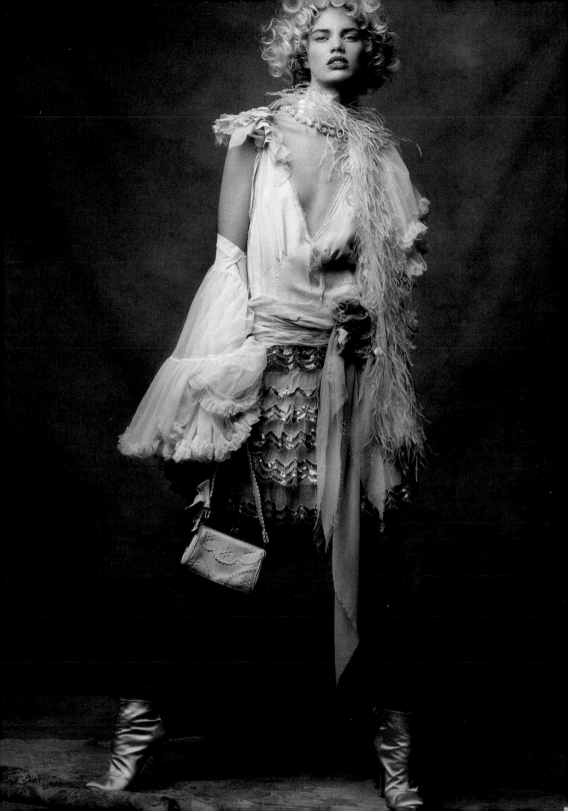

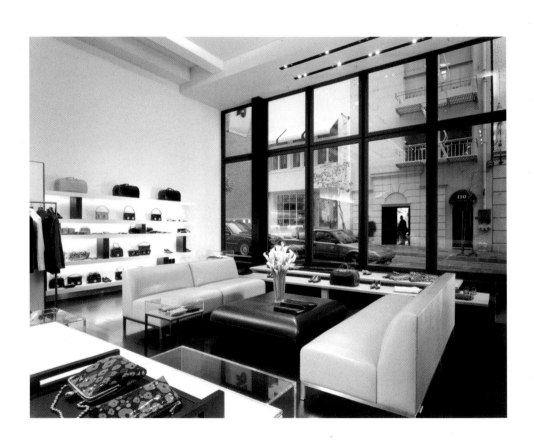

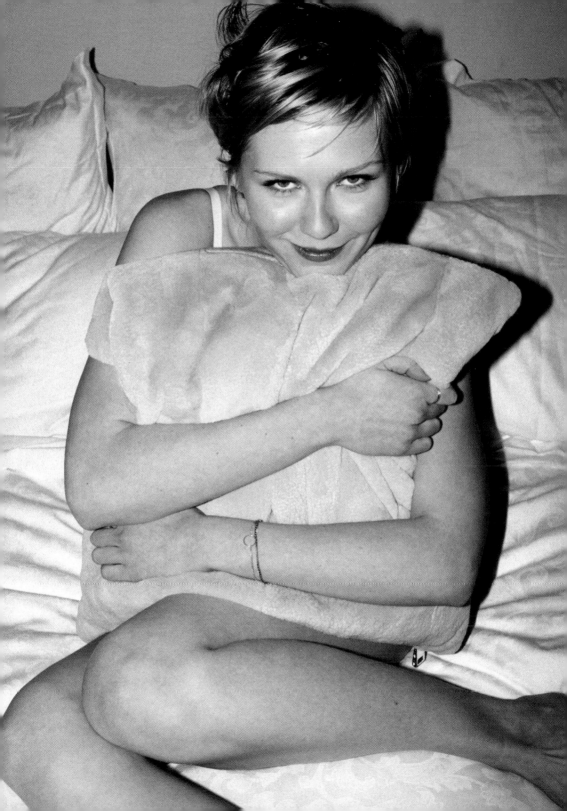

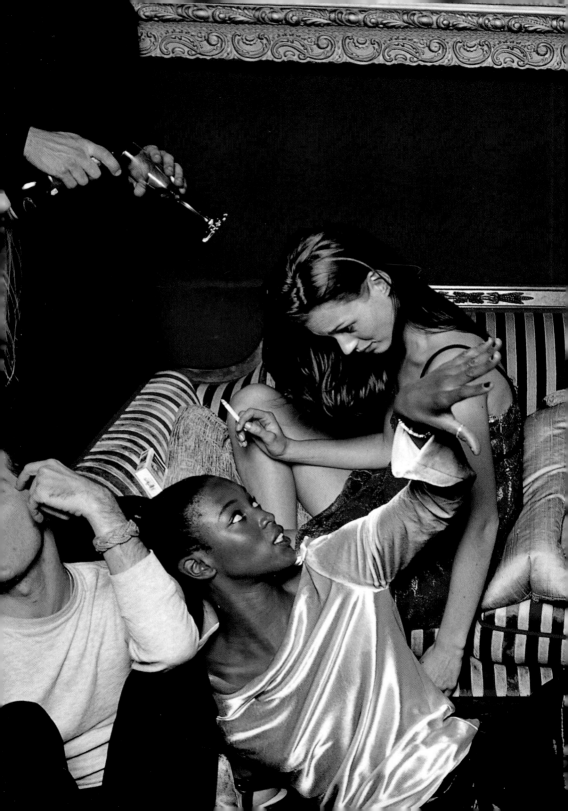

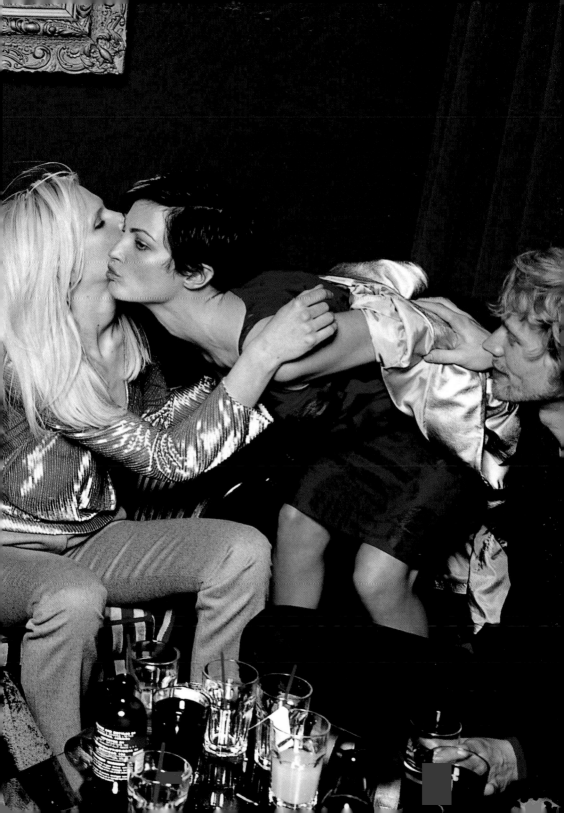

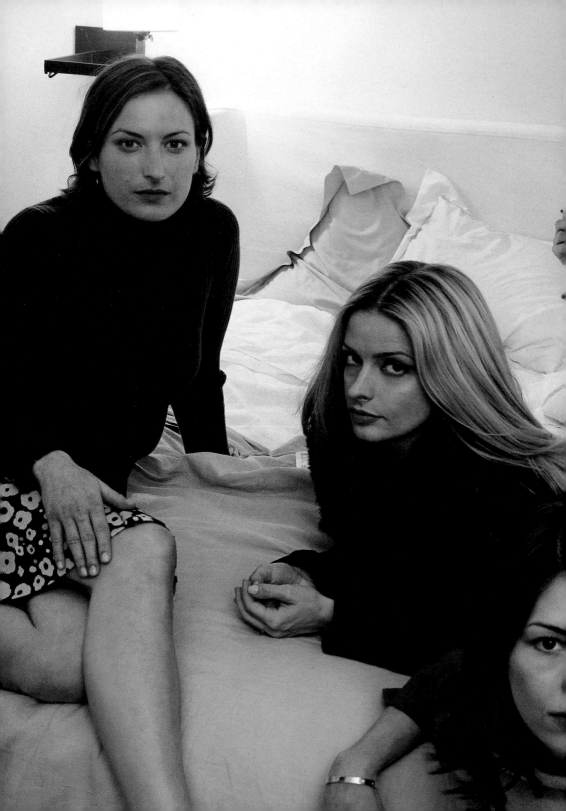

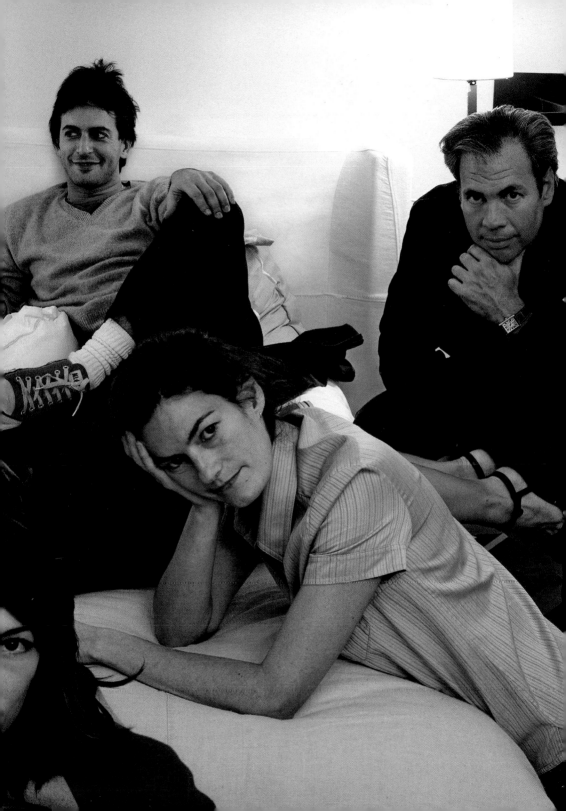

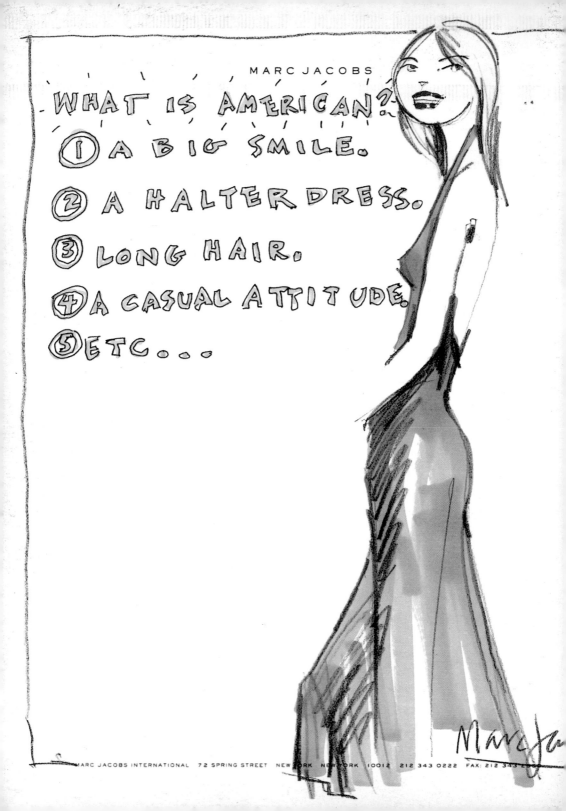

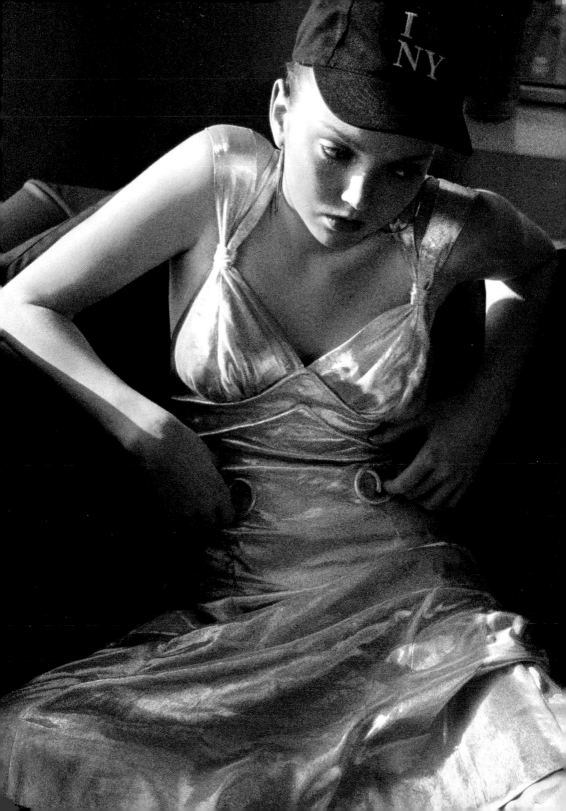

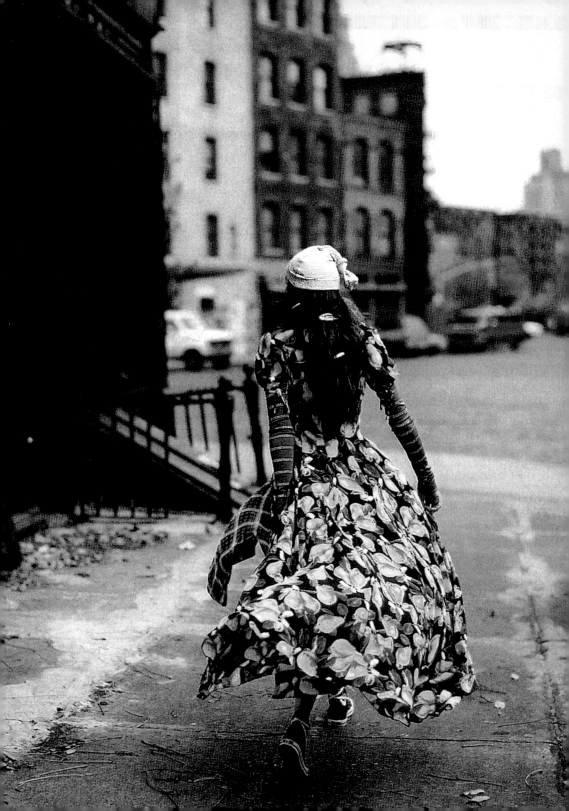

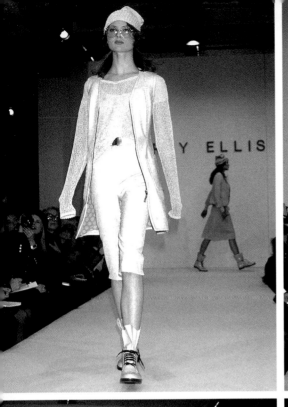

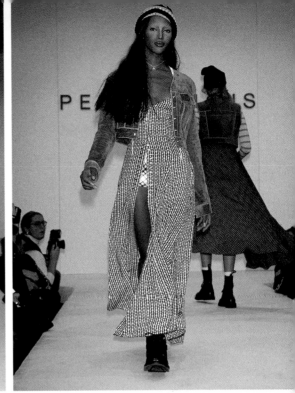

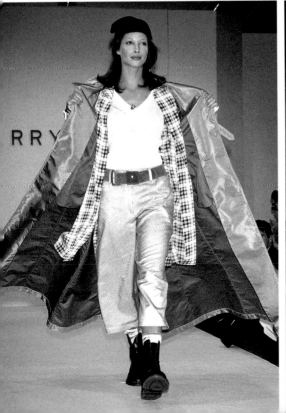

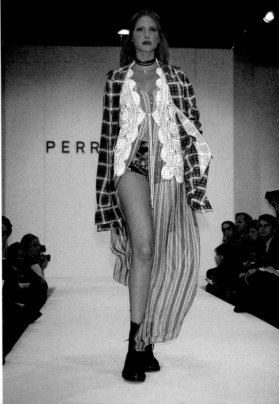

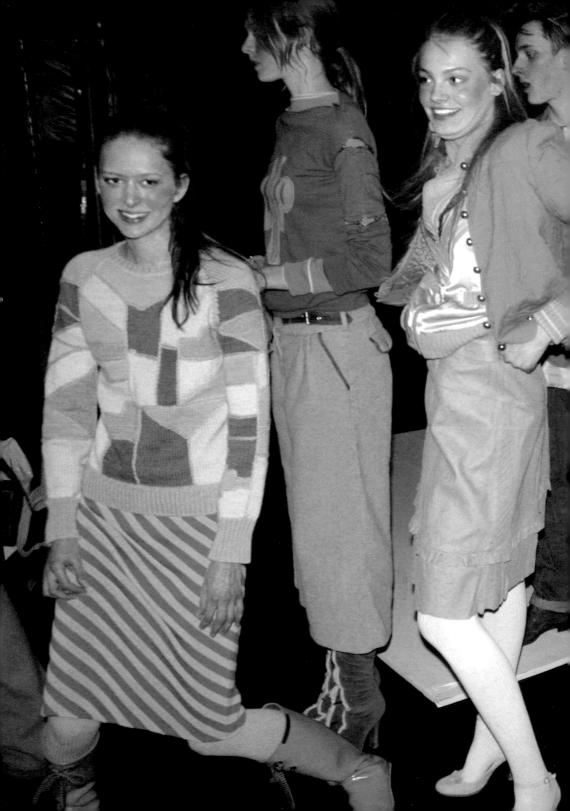

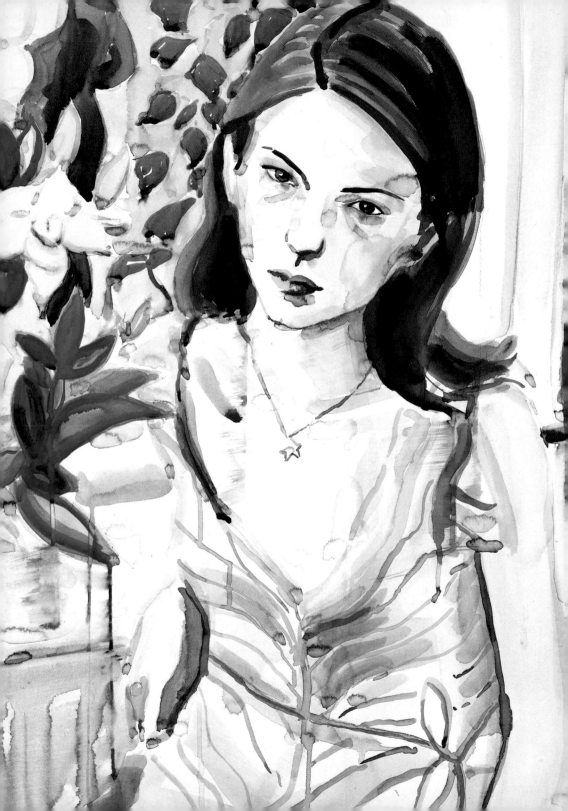

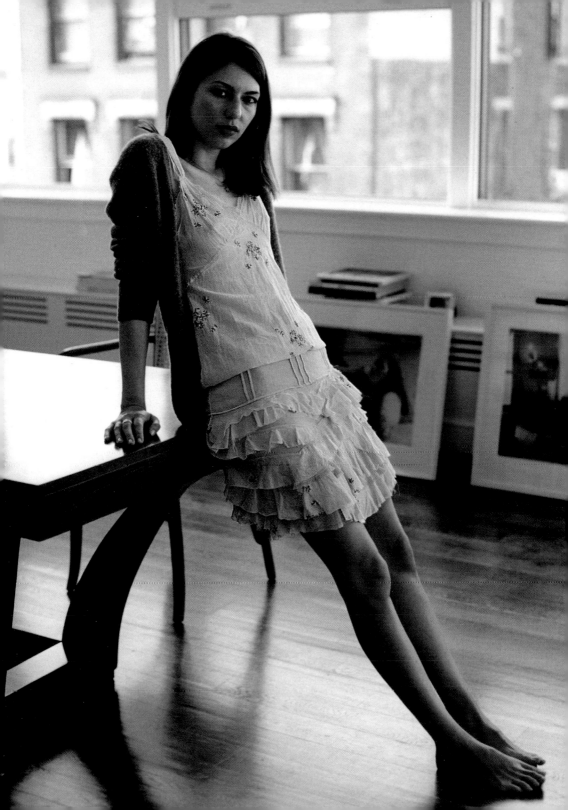

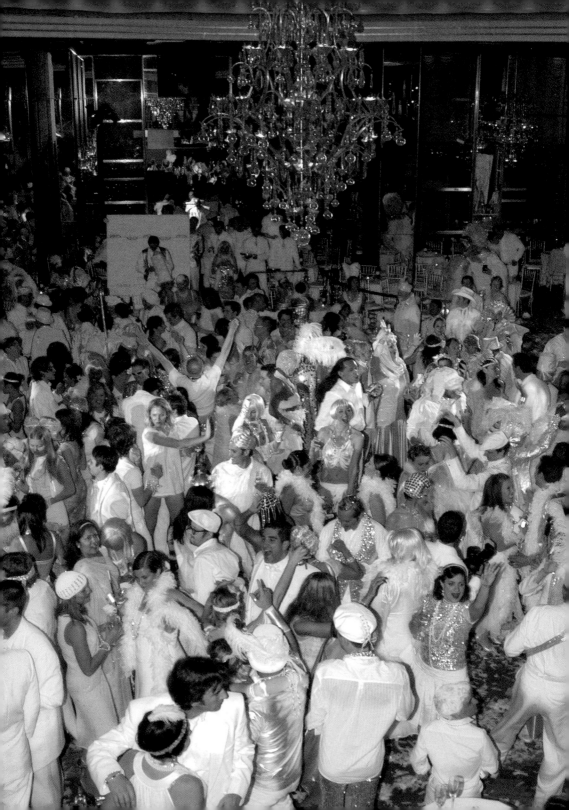

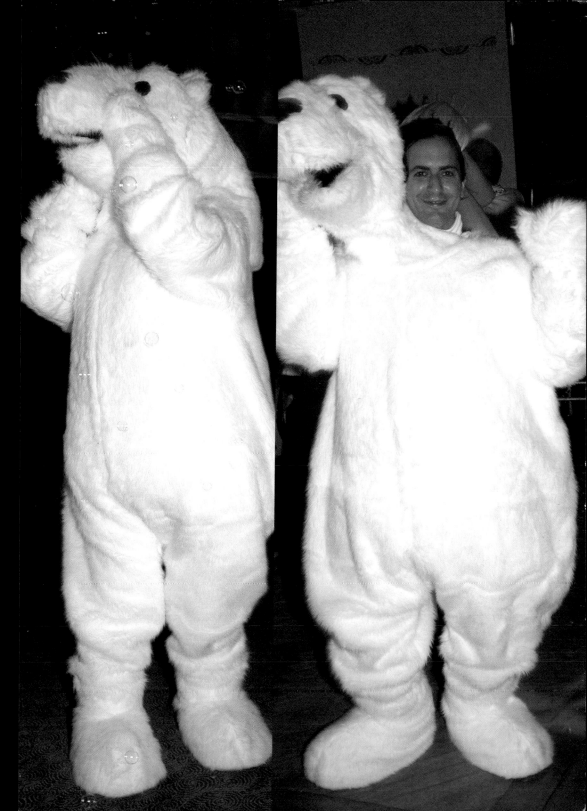

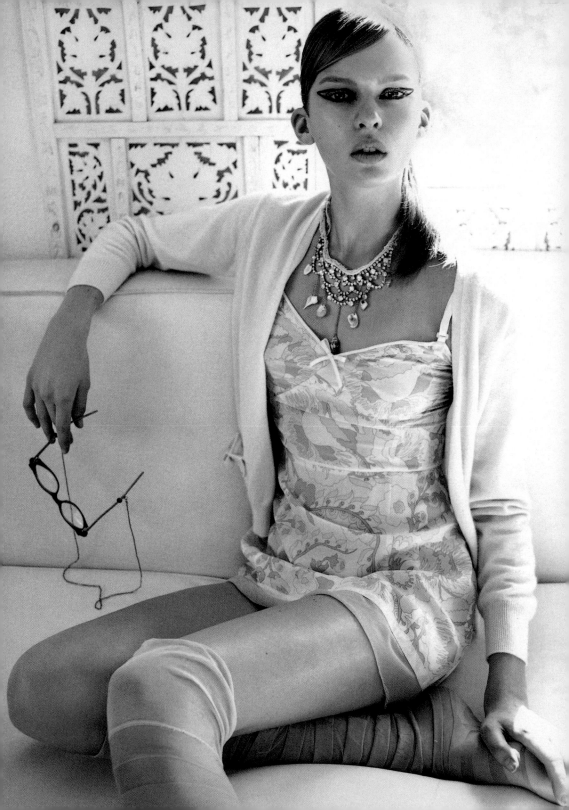

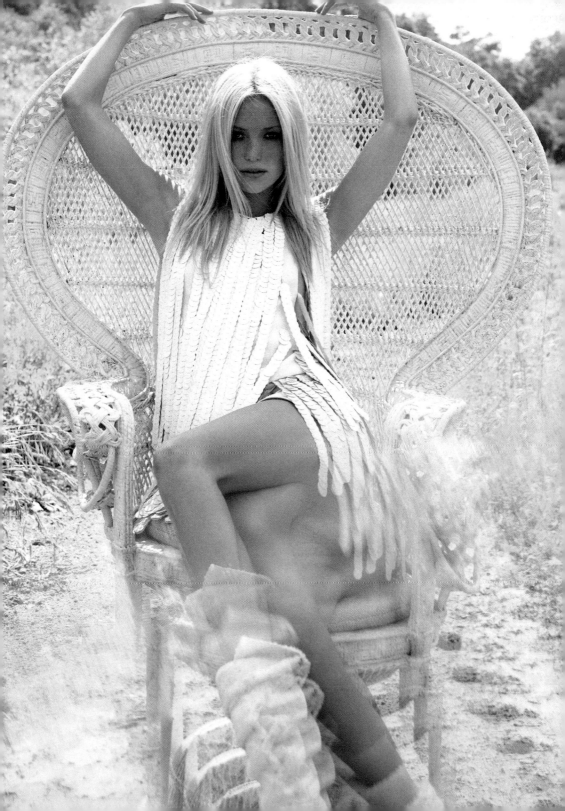

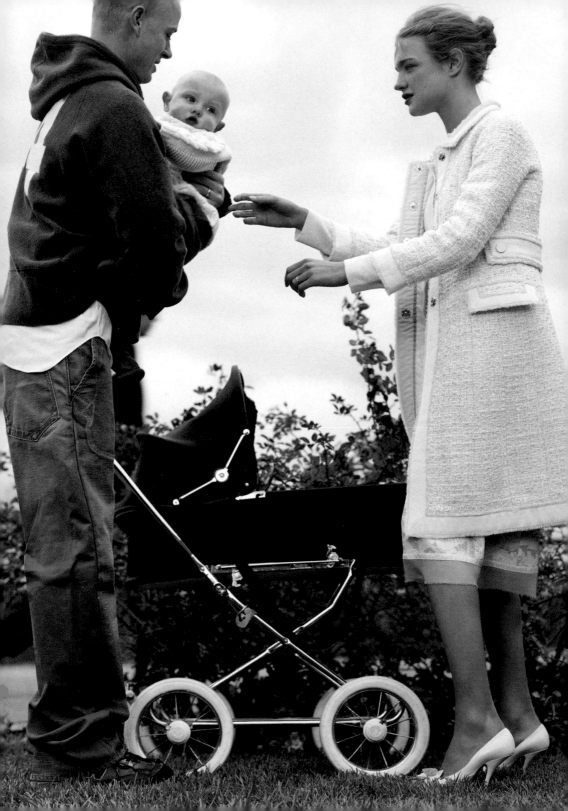

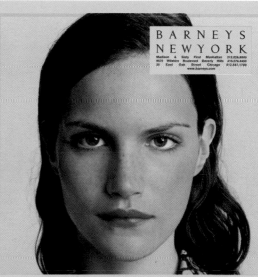

Girls Love Marc Jacobs

Boys Love Marc Jacobs

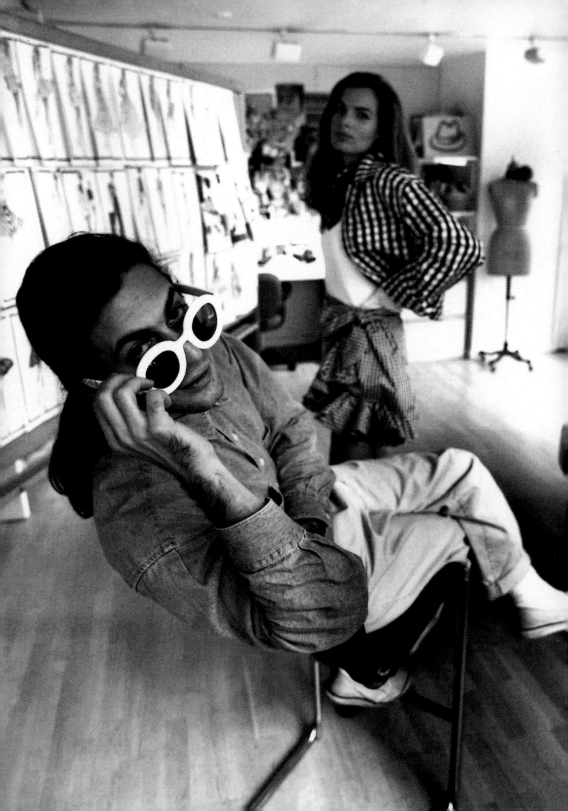

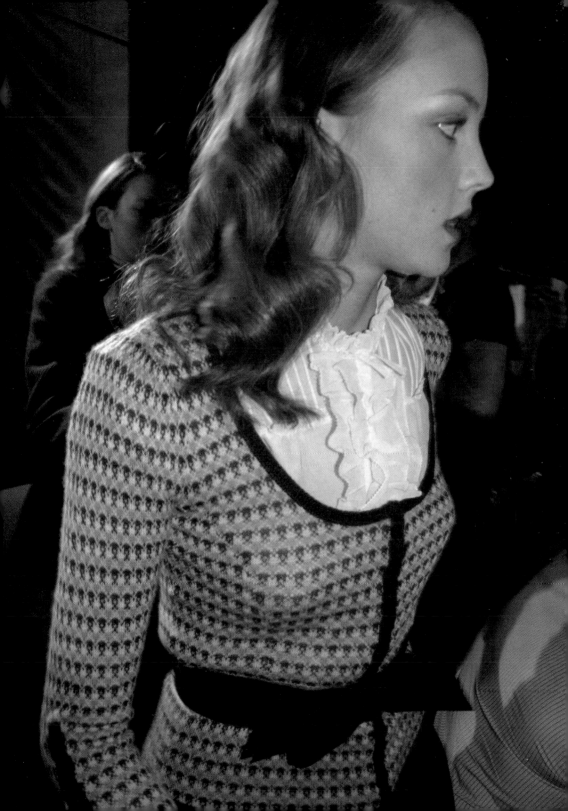

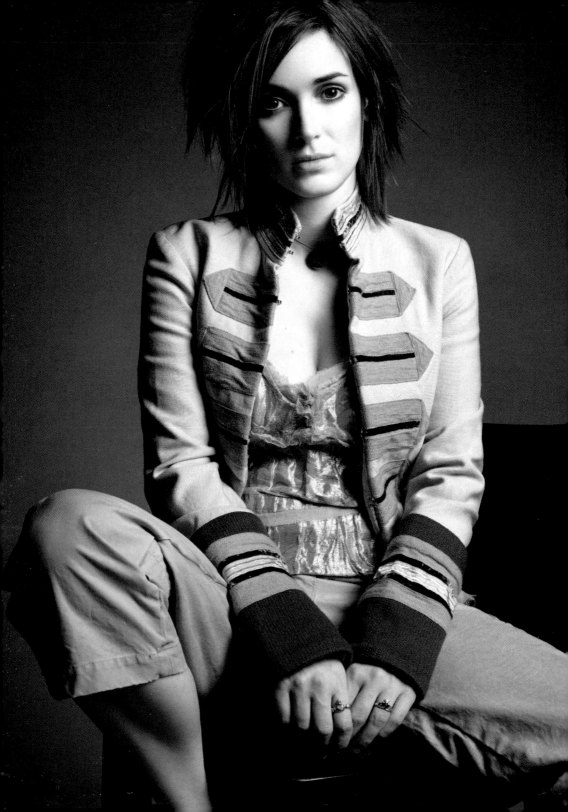

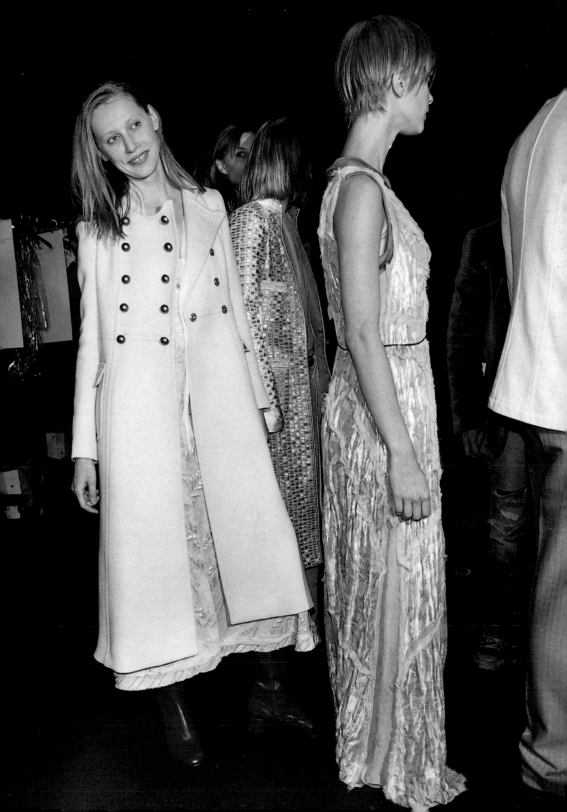

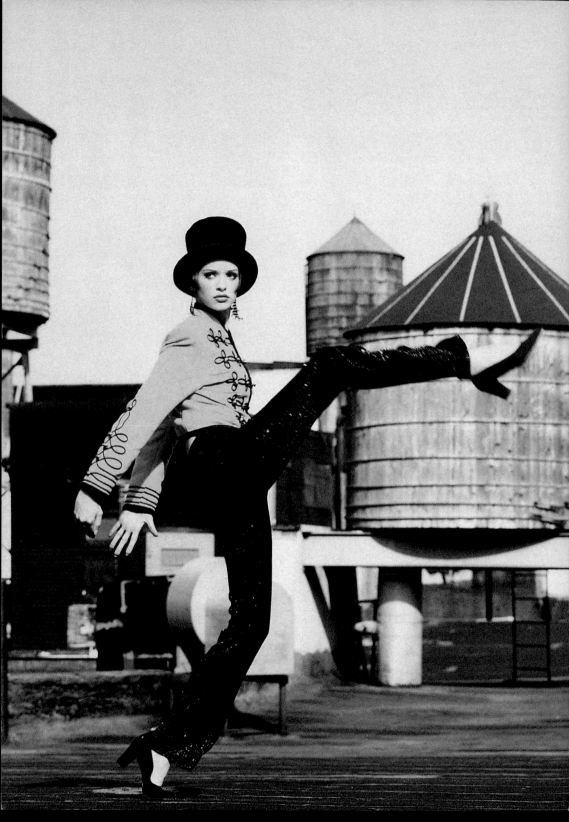

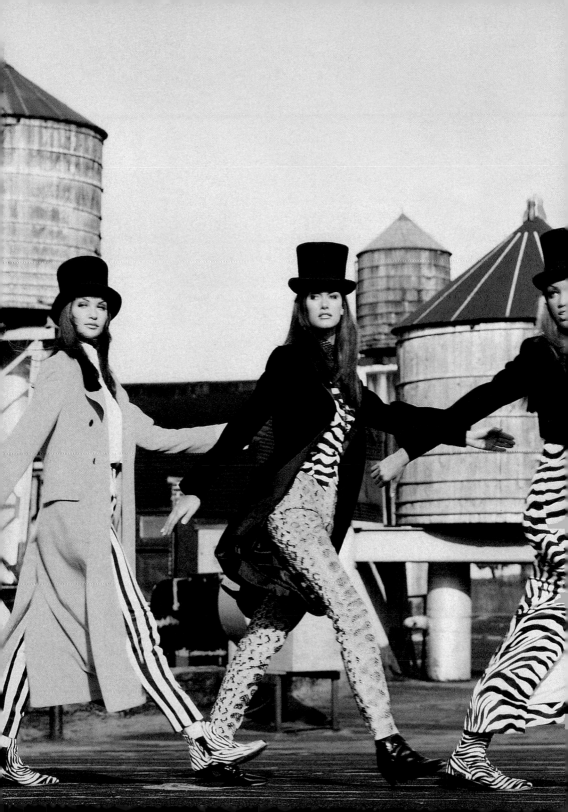

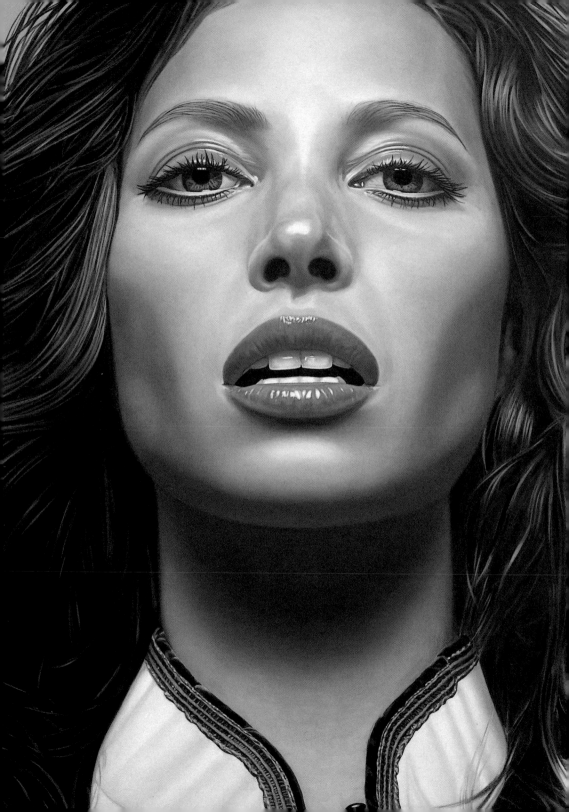

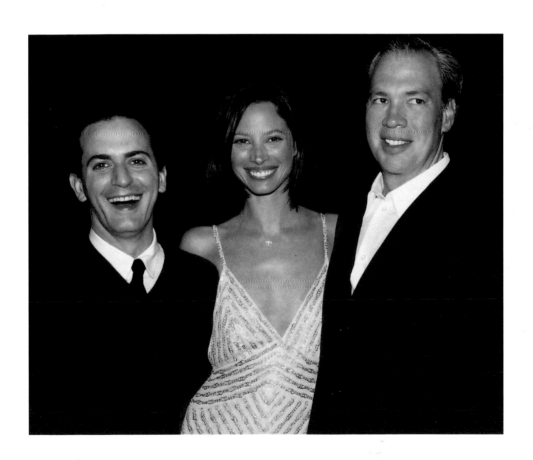

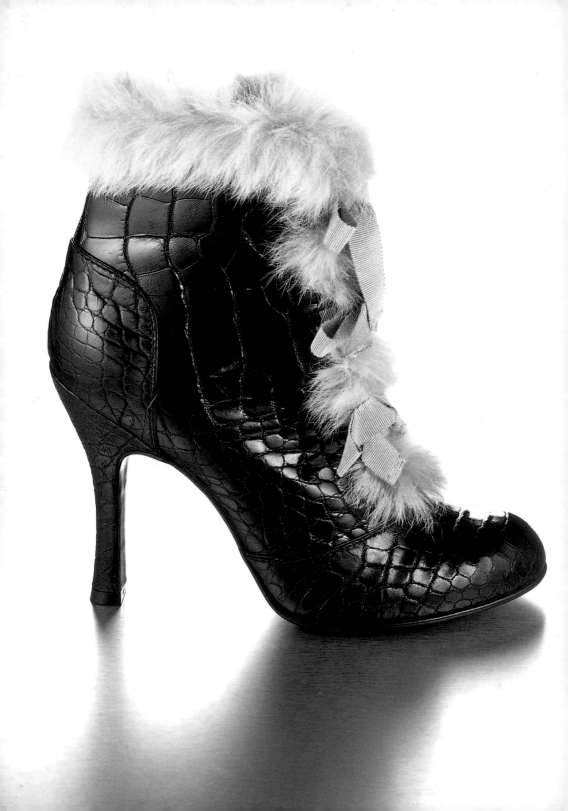

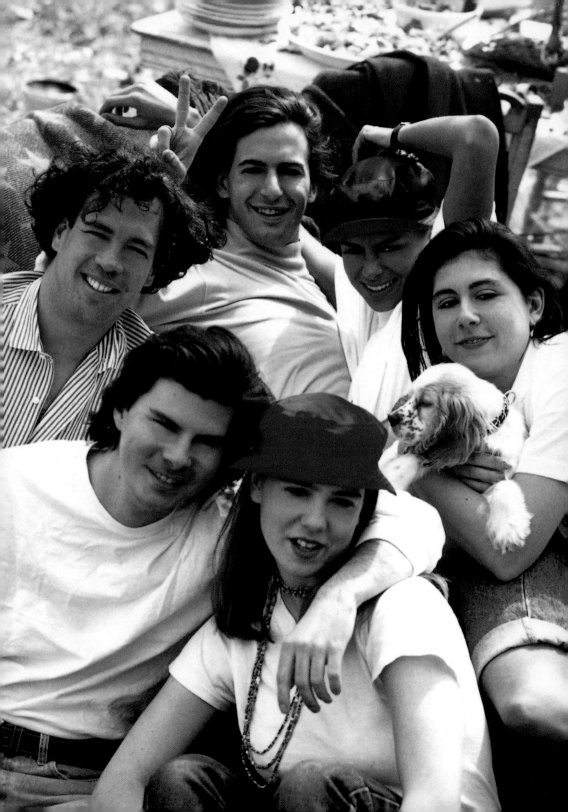

I LOVE YOU, ROBERT!

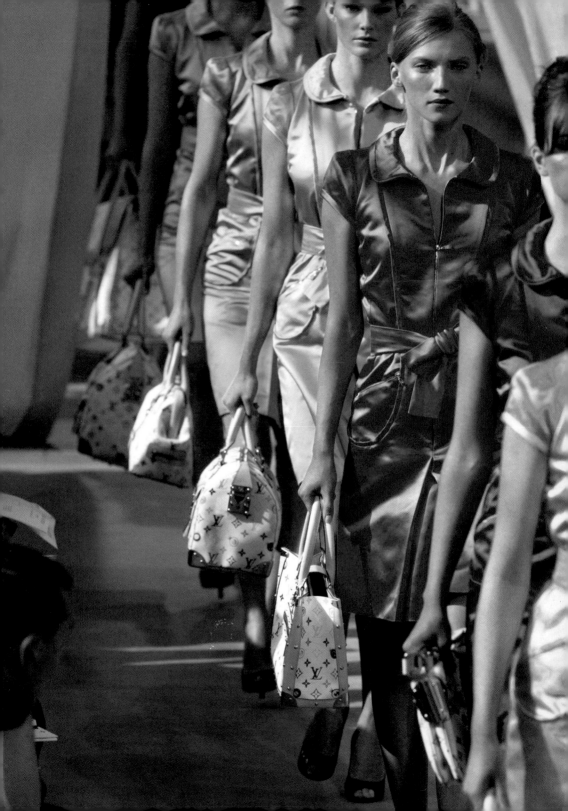

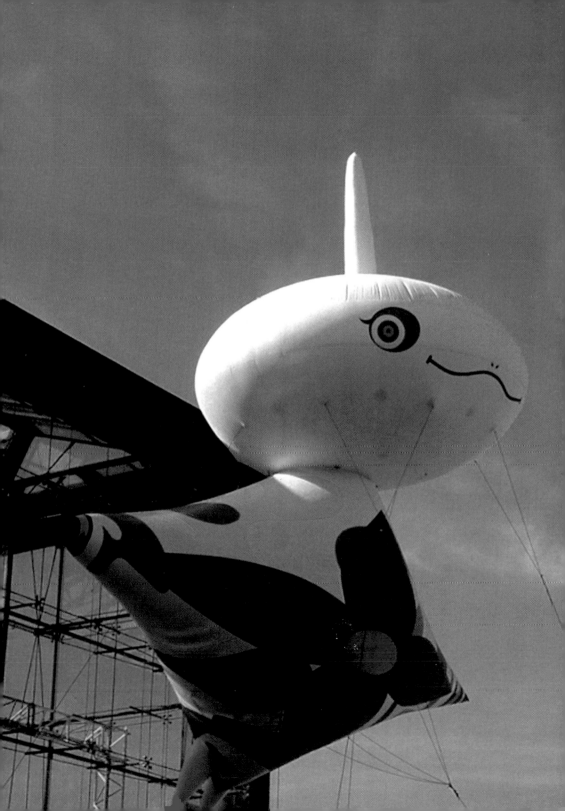

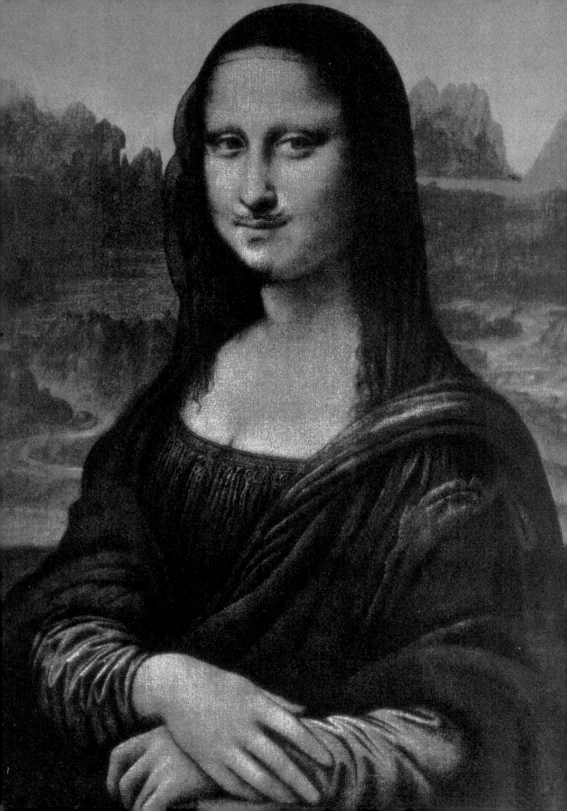

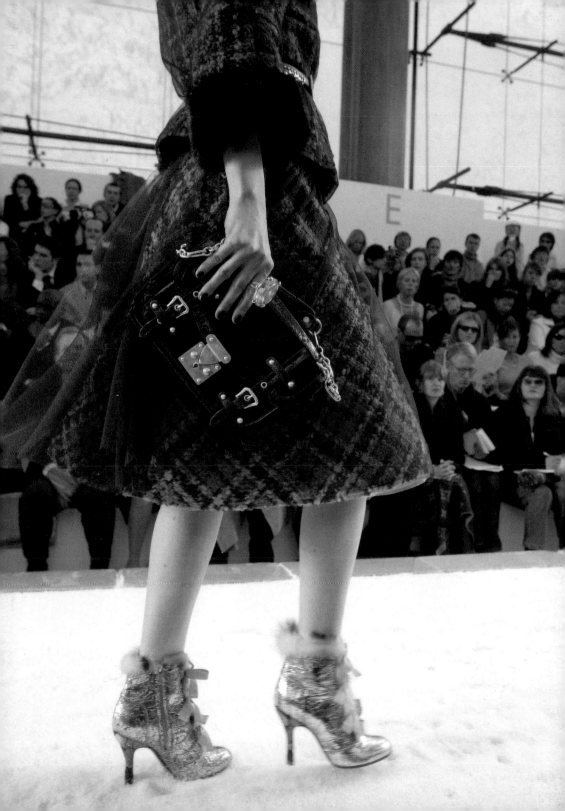

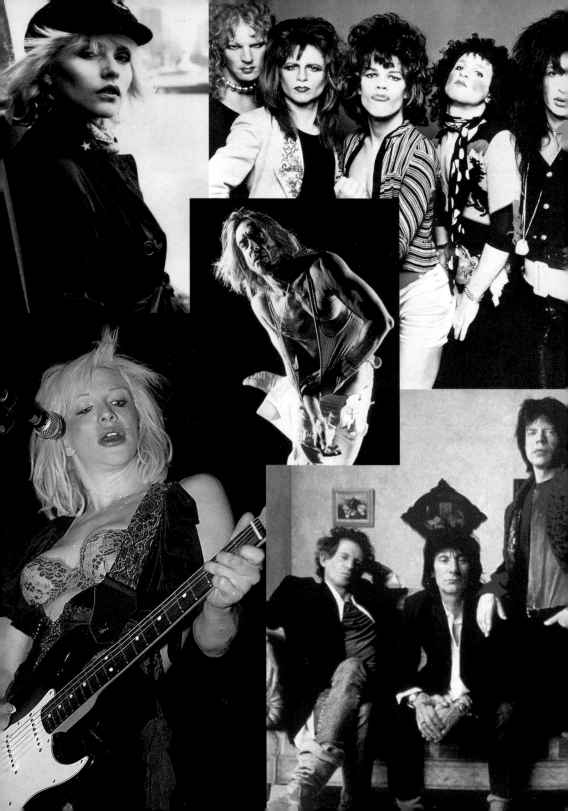

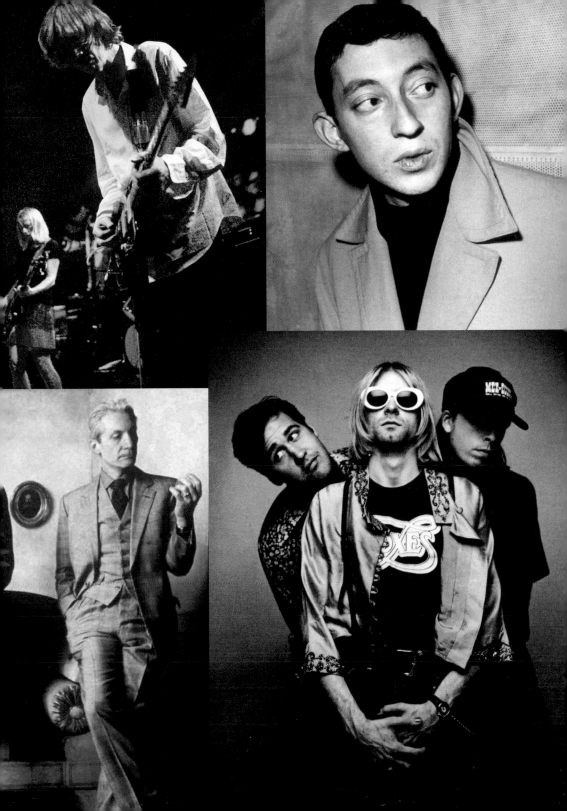

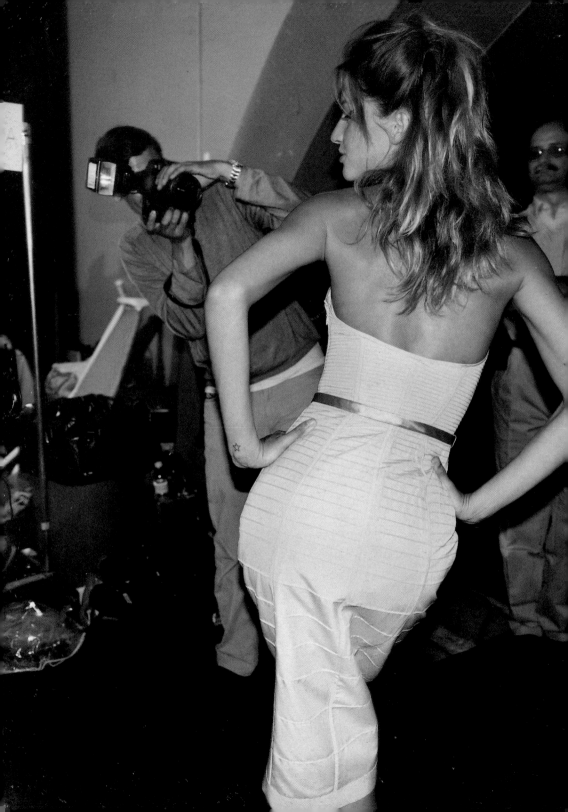

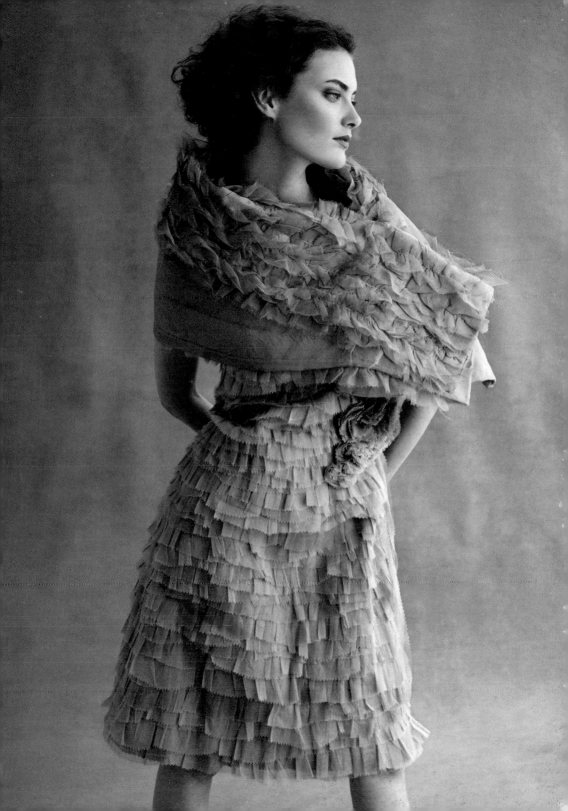

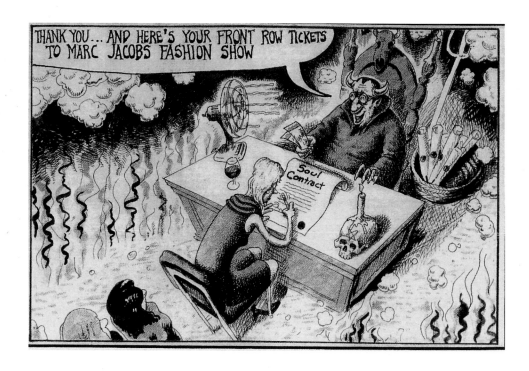

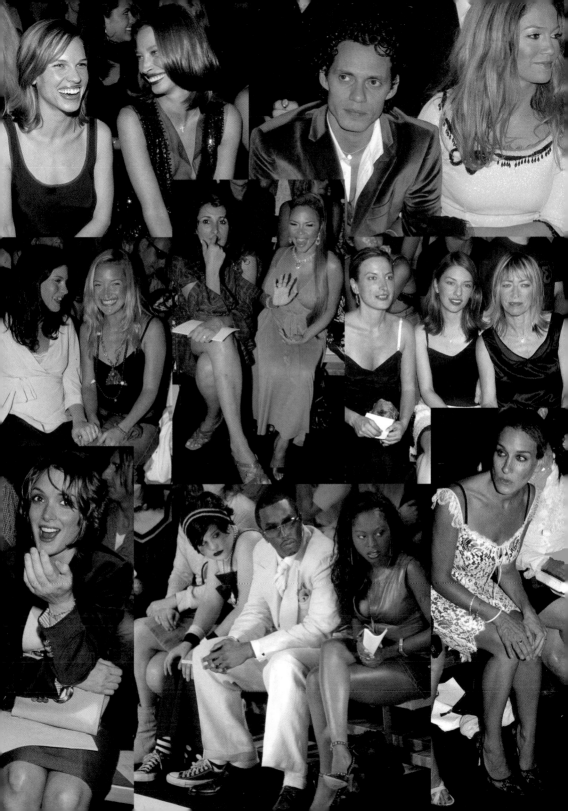

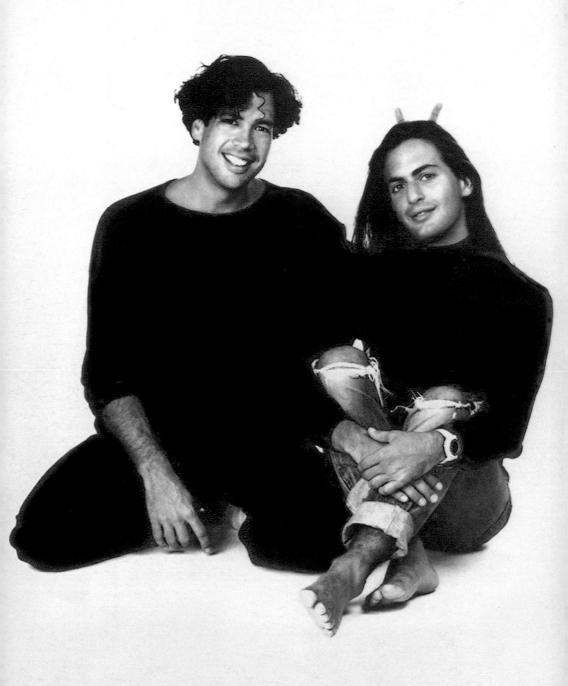

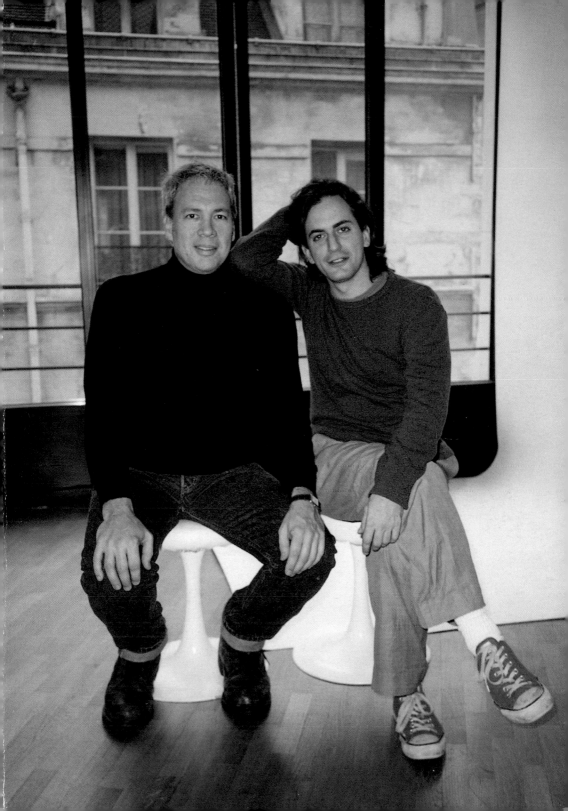

Chronology

1963: Marc Jacobs is born in New York City on April 9.

1981: Jacobs graduates from the High School of Art & Design.

1984: Marc Jacobs graduates from Parsons School of Design and is awarded three of the school's highest honors: The Perry Ellis Gold Thimble Award, The Chester Weinberg Gold Thimble Award, and Design Student of the Year.
Jacobs designs his first collection under the Sketchbook label, backed by Ruben Thomas.
Forms Jacobs Duffy Designs, Inc., with Robert Duffy in a fifty-fifty partnership.

1986: Jacobs designs his first collection under the Marc Jacobs label, backed by Kashiyama USA, Inc.

1987: The Council of Fashion Designers of America awards Jacobs the Perry Ellis Award for new fashion talent.

1988: Jacobs and Duffy join Perry Ellis as vice president of design and president of Perry Ellis Women, respectively.

1992: Jacobs rocks fashion with his famed grunge collection for Perry Ellis for the Spring 1993 season. It garners him the CFDA Womenswear Designer of the Year Award and a pink slip from Perry Ellis.

1993: Jacobs Duffy Designs, Inc. becomes Marc Jacobs International Company, L.P., in which Jacobs and Duffy maintain their fifty-fifty partnership.

1994: Marc Jacobs International Co., L.P., signs its first licensing agreement, with Renown Look and Mitsubishi, for distribution in Japan.
Launches women's and men's shoe collections.

1997: The company launches its men's wear collection.
Jacobs and Duffy join Louis Vuitton as creative director and studio director, respectively. LVMH buys a one-third interest in Marc Jacobs Trademarks and a majority interest in Marc Jacobs International, LLC.
The first freestanding Marc Jacobs store opens at 163 Mercer Street in New York.
Jacobs wins the CFDA Womenswear Designer of the Year Award for Marc Jacobs Collection.

1998: Jacobs receives the VH1 Fashion Award's Women's Designer of the Year for Marc Jacobs Collection.

1999: Jacobs wins the CFDA Accessory Designer of the Year Award.

2000: The company launches women's and men's accessories.
Stores open in San Francisco and Osaka, Japan.
Juergen Teller shoots the first advertising campaign for the Marc Jacobs label, featuring Sofia Coppola.
The first men's collection store opens at 403 Bleecker Street in New York. This is the beginning of what will become a street of shops for the brand.
Marc by Marc Jacobs, the company's secondary collection, launches for women and men simultaneously.

Fall 2000 ad campaign featuring Kate Moss.
© Juergen Teller.

2000: Jacobs collaborates with Stephen Sprouse on accessories for Louis Vuitton, Spring 2001.

2001: Marc Jacobs Perfume, the company's first fragrance, debuts.
Marc by Marc Jacobs store opens at 405 Bleecker Street.
Jacobs wins his second VH1/Vogue Designer of the Year award for his Marc Jacobs Women's Collection.
Jacobs collaborates with Julie Verhoeven on accessories for Louis Vuitton, Spring 2002.

2002: Marc Jacobs accessories store opens at 385 Bleecker Street.
Store opens in Aoyama, Tokyo, carrying all Marc Jacobs products. Collection stores open in Hong Kong and Taiwan.
Jacobs wins CFDA Menswear Designer of the Year Award for Marc Jacobs.
The company launches Marc Jacobs Men fragrance.
Jacobs collaborates with Takashi Murakami on accessories for Louis Vuitton, Spring 2003.

2003: Jacobs receives CFDA Accessories Designer of the Year Award for Marc Jacobs.
The company launches its second women's fragrance, Marc Jacobs Essence, and its Home Collection.

2004: Marc Jacobs stores open in Boston and in Shanghai, China; Marc by Marc Jacobs store opens in Beijing.
Marc Jacobs and Marc by Marc Jacobs stores open Los Angeles.
The company launches women's and men's eyewear and watch collections, as well as its third women's fragrance, Blush by Marc Jacobs.
Jacobs and Duffy celebrate their twenty-year partnership in the Marc Jacobs business.

Fall 2001 ad campaign featuring Stephanie Seymour.
© Juergen Teller.

Marc Jacobs

Christy Turlington and Naomi Campbell in skirts by Marc Jacobs for Perry Ellis, Spring 1992. Photographed at the Parlange Plantation in Louisiana. © Arthur Elgort/*Vogue*.

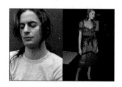

Marc Jacobs. © Steven Klein/*W*, 1996.
Eugenia Volodina backstage at Marc Jacobs, Fall 2004. © Kyle Ericksen/*WWD*.

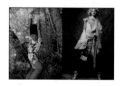

Naomi Campbell in Marc Jacobs for Perry Ellis, Spring 1992. © Patrick Demarchelier/*Vogue*.
Rianne Ten Haken in Marc Jacobs, Spring 2004. © Craig McDean/*W*.

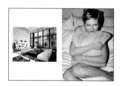

Marc Jacobs store interior, 125 Maiden Lane, San Francisco. © Paul Warchol, 2000.
Kirsten Dunst with a pillow from the Marc Jacobs Home Collection. © Sofia Coppola/British *Esquire*, 2004.

Marc Jacobs with models in Marc Jacobs, Fall 1996. From left to right: Kristy Hume, Naomi Campbell, Kate Moss, Christina Kruse, and Chandra North. © Annie Leibowitz/Contact Press Images.

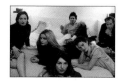

Marc Jacobs and friends. From left to right: Zoe Cassavetes, Lisa Marie, Sofia Coppola, Venetia Scott, and Robert Duffy. © Annie Leibowitz/Contact Press Images.

Sketch by Marc Jacobs for *WWD*, Spring 2002. © Marc Jacobs Archives.
Lily Cole in Marc Jacobs, Spring 2004. © Inez van Lamsweerde and Vinoodh Matadin/*W*.

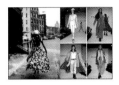

Marc Jacobs for Perry Ellis, Spring 1993 grunge collection. © Walter Chin/ *Mademoiselle*.
Runway grunge at Perry Ellis, Spring 1993. © *Vogue*/Condé Nast Archive.

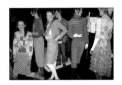

Backstage at Marc by Marc Jacobs, Fall 2004. From left to right: Shelly Zander, Elise Crombez, Anna J., Adina Fohlin and Rianne Ten Haken. © Kyle Ericksen/ *WWD*.

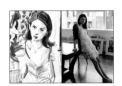

Watercolor portrait of Sofia Coppola by Elizabeth Peyton, 2003, used in print campaign for the Marc Jacobs fragrance Essence. © Elizabeth Peyton.
Sofia Coppola in Marc Jacobs. © Paul Jasmin/*W*, 2003.

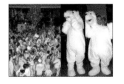

"The Art Deco Glitter Ball." Marc Jacobs company holiday party at the Rainbow Room in New York City, December 16, 2003. © Steve Eichner/*WWD*.
Marc Jacobs in a polar bear costume bought on the Internet for $600. © Steve Eichner/*WWD*.

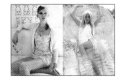

Elise Crombez in Marc Jacobs, Spring 2003. © Michael Thompson/*W*.
Kate Hudson in Marc Jacobs, Fall 2003. © Michael Thompson/*W*.

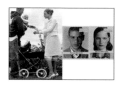

Natalia Vodianova, in Marc Jacobs, Spring 2003, with husband Justin Portman and son Lucas. © Steven Klein/*Vogue*.
Barneys New York ad campaign for Marc Jacobs, Fall 2000. © Tom Munro.

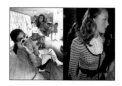

Marc Jacobs and model in Perry Ellis, Spring 2002. © David Turner/*W*.
Heather Marks backstage at Marc Jacobs, Fall 2004. © Kyle Ericksen/*WWD*.

Winona Ryder in Marc Jacobs, Fall 2002. © Michael Thompson/*W*.
Backstage at Marc Jacobs, Fall 2002. © Robert Fairer.

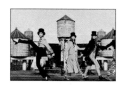

Marc Jacobs for Perry Ellis, Fall 1992. © Max Vadukul/*Vogue*.

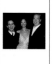

Christy Turlington portrait, in oil, by Richard Phillips after a photograph by Inez van Lamsweerde and Vinoodh Matadin. Both for *V*, Fall 2002. © Courtesy Richard Phillips.
Marc Jacobs, Christy Turlington, and Robert Duffy at a Cancer Care Dinner at the Waldorf Astoria, May 2002. © Marc Jacobs Archives.

Louis Vuitton fur-trimmed alligator boot, Fall 2004. © John Aquino/*W*.
Meg White of the White Stripes. © Rufus F. Folkks/Corbis, 2002.

Good times at Perry Ellis. Clockwise from top: Marc Jacobs, model Melanie Landestoy, Anita Antonini with Princess, Susan Goldsmith, Duncan Snitkin, and Robert Duffy. © Bob Frame/*Harper's Bazaar*.
Note of affection from Marc Jacobs's English bull terrier, Alfred, to Robert Duffy, 2002. © Marc Jacobs Archives.

Louis Vuitton runway featuring variations on the Murakami bag, Spring 2003. © Giovanni Giannoni/WWD.
Takashi Murakami balloon outside the show space at the Serre du Parc Andre Citroen. © Giovanni Giannoni/WWD.

Marcel Duchamp's L.H.O.O.Q., 1919, one of Jacob's favorite paintings. 1955 version, collection Angelo Calmarini, Milan. © Cameraphoto/akg-images/ADAGP, Paris 2004.
Detail from Louis Vuitton runway, Fall 2004. © Stephane Feugere/WWD.

Marc Jacobs's musical inspirations: Deborah Harry, 1979 © Evening Standard/Getty; Iggy Pop, 2003 © Mark Mann New York Dolls, 1974 © Bettman/Corbis; Sonic Youth in concert at the Ogden Theatre, Denver, CO, 2002 © Soren McCarty/Wirelmage; Serge Gainsbourg, 1958 © Pierre Fournier/Corbis; Courtney Love at the Bowery Ballroom in NYC, 2004 © Lorenzo Ciniglio/Corbis; The Rolling Stones © The Associated Press, 1994; Nirvana, 1993 © Anton Corbijn.

Giselle Bündchen backstage at Marc Jacobs, Spring 2003. © Robert Fairer.
Shalom Harlow in Marc Jacobs, Fall 2000. © Michael Thompson/Vogue.

Cartoon by Sean Delonas. The New York Post, February 7, 2002. © Sean Delonas. Front row: Hilary Swank and Christy Turlington, 2003 © Evan Agostini/Getty; Marc Anthony and Jennifer Lopez, 2005 © Dimitrios Kambouris/Wire Image; Liv' Tyler and Kate Hudson, 2005 © Courtesy Patrick McMullan; Lil Kim and friend, 2005 © Courtesy Patrick McMullan; Zoe Cassavetes, Sofia Coppola, Kim Gordon, 2004 © Scott Gries/Getty; Winona Ryder, 2001 © Pace Gregory/Corbis Sygma; Kelly Osbourne, Sean "P.Diddy" Combs and Foxy Brown, 2003 © Evan Agostini/ImageDirect; Sarah Jessica Parker, 2002 © Dan D'Errico/WWD.

Robert Duffy and Marc Jacobs, 1987. © Marc Jacobs Archives.
Robert Duffy and Marc Jacobs, March 2002. © Pierre Bailly.

The publisher would like to thank Marc Jacobs and his team who helped in the realization of this book, and in particular Camille Micelli, Venessa Lau, Vanessa Lawrence, Kate Waters, and David Yassky.

Additional thanks to Evan Agostini, Anna J., Anita Antonini, John Aquino, Pierre Bailly, Giselle Bündchen, Naomi Campbell, Zoe Cassavetes, Walter Chin, Lorenzo Ciniglio, Lily Cole, Sean "P. Diddy" Combs, Sofia Coppola, Elise Crombez, Jennifer Cwiok, Claire Danes, Sean Delonas, Patrick Demarchelier, Robert Duffy, Kirsten Dunst, Steven Eichner, Arthur Elgort, Kyle Ericksen, Dan D'Errico, Robert Fairer, Stephane Feugere, Adina Fohlin, Rufus F. Folkks, Pierre Fournier, Foxy Brown, Bob Frame, Ron Frasch, Giovanni Giannoni, Susan Goldsmith, Kim Gordon, Pace Gregory, Scott Gries, Rianne Ten Haken, Deborah Harry, Kate Hudson, Kristy Hume, Iggy Pop, Paul Jasmin, Steven Klein, DeLano L. Knox and Margaret Skeeter from the Fairchild Library Archives, Christina Kruse, Inez van Lamsweerde and Vinoodh Matadin, Annie Leibowitz, Lisa Marie, Melanie Landestoy, Courtney Love, Heather Marks, Soren McCarty, Craig McDean, Kate Moss, Tom Munro, Takashi Murakami, The New York Dolls, Nirvana, Chandra North, Kelly Osbourne, Sarah Jessica Parker, Elizabeth Peyton, Richard Phillips, Terry Richardson, The Rolling Stones, Eric Russ of *W* and *WWD*, Winona Ryder, Venetia Scott, Stephanie Seymour, Duncan Snitkin, Sonic Youth, Michael Stier from Condé Nast Archives, Hilary Swank, Juergen Teller, Michael Thompson, Christy Turlington, David Turner, Max Vadukul, Natalia Vodianova, Eugenia Volodina, Paul Warchol, Meg White, and Shelly Zander.